This catalog is made possible due to the generous support of donors to SAQA's Endowment Fund. SAQA would particularly like to thank these individuals and named funds for their generosity;

Mary Anhaltzer Memorial Fund (Herb Anhaltzer)

Lisa Ellis, in memory of Judith House

Ralph and Janice James

Jean Ray Laury Memorial Fund (Karey Bresenhan)

Shirley Neary

ISBN: 978-0-9896896-2-5

Catalog design by Deidre Adams

Printed in China

SAQA™
Studio **Art** Quilt Associates

PO Box 572
Storrs, CT 06268-0572
860.487.4199

www.saqa.com

Juror's essay

In the last quarter of the twentieth century, quilts were removed from the bed and hung on walls of museums and galleries. This dramatic shift in placement led to changes in the size and shape of a quilt. Artists who chose to work within the genre of quilts began to invent their own decorative surfaces, whether designing a new geometry or creating their own graphically exciting work in fiber. Instead of relying on a traditional block pattern to identify a quilt, art quilts were recognized by the quilt's title, the maker's name, and the artistic concept and design originality.

Celebrating Silver celebrates the 25th anniversary of Studio Art Quilt Associates, Inc. (SAQA). I founded SAQA in 1989 to provide a professional organization for artists creating art quilts. This exhibition provided an opportunity to look back and reflect on how things have changed.

Each artist submitted six digital images, three full pieces and three details, which were typical of their current style of work. My goal was not to select a specific work by the artist but rather to trust that the artist would individualize the theme with a variety of new and exciting techniques.

Names of the artists were not revealed to me until after the selection process.

I kept notes as I scrolled through the 300 images, returning many times to individual artist's images, scrutinizing the work, identifying the voice of the artist. I reread statements from the artists who gave a hint of what they would like to accomplish within the theme. Techniques new to the 21st century dominated the entries — use of electronic manipulation, painting, dyeing, texture within the fabric, copious use of machine threads, photography — yet there was also a link to tradition with piecing and hand stitching. I am excited to join you all as we enjoy the debut of *Celebrating Silver* at the International Quilt Festival Houston, October 2014.

—Yvonne Porcella

Yvonne Porcella is the Founder and served as President of the Board of Directors of Studio Art Quilt Associates from 1989-2000. She has also served on the boards of other non-profit organizations. Her work continues to be featured in major exhibitions, art galleries, and museums in the U.S. and abroad and is actively collected by individuals and corporations. She has been a juror of quilt/fiber art exhibitions Quilt National, IQA, AQS, and PNQF.

Curator's essay

When Yvonne Porcella asked if I would be the curator for *Celebrating Silver*, how could I say no? It has been a great honor and privilege to work with her throughout the process of developing the silver anniversary concept and exhibition guidelines, reviewing her list of selected artists and finally seeing the work realized.

Silver is indispensable. From industrial use to decoration, technology, photography and medicine, its unique properties of strength, malleability, reflectivity and conductivity make it an irreplaceable force in the global market. In addition to its physical properties silver is recognized as a symbol of love, insurance and commitment for twenty-five years. We invite you to share your reflections on the precious metal's economic and symbolic value in order to celebrate SAQA's 25th anniversary.

Based on this call for consideration, artists submitted images of current work along with a proposal for how they would interpret the theme "silver." From a talented pool of entries, Yvonne selected 35 artists to create work specifically for this exhibition.

In addition to their quilt, each artist provided documentation that included their sources of inspiration, photos, sketches, fabric samples and descriptions of techniques. These pages have been compiled into a book that will travel with the exhibition. Exhibition visitors will want to look at these fascinating documents that provide a glimpse into each artist's creative process and give valuable insight into the art works in this exhibition.

Despite the unifying guidelines of theme and size limitations dictated by exhibition venues, the resulting art works display a great variety of styles, techniques and artists' concepts. Thank you to every one of these artists, who have together created an exhibition that not only honors SAQA's significant milestone but also does indeed shine bright!

—Nancy Bavor

Nancy Bavor has been a quilt maker, collector and teacher for over 25 years. Currently she serves as the Curator of Collections at the San Jose Museum of Quilts & Textiles and is an American Quilter's Society Certified Appraiser of Quilted Textiles. She holds a Bachelors degree in art history from Northwestern University and a Masters degree from the University of Nebraska, Lincoln in the History of Textiles/Quilt Studies emphasis. Nancy also serves on the boards of Studio Art Quilt Associates and The Quilt Alliance.

the
artists

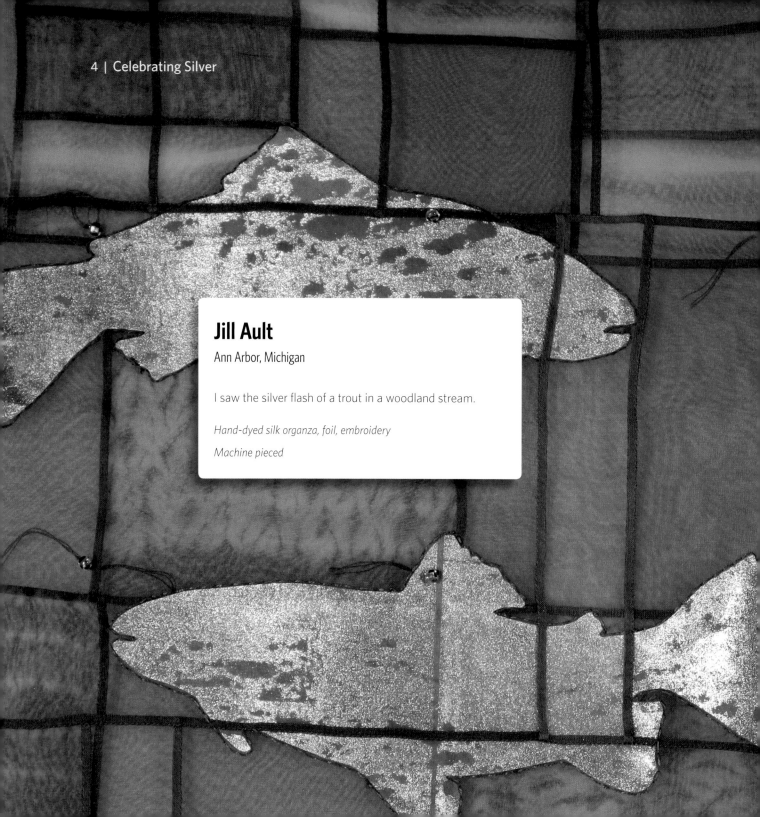

Jill Ault

Ann Arbor, Michigan

I saw the silver flash of a trout in a woodland stream.

Hand-dyed silk organza, foil, embroidery

Machine pieced

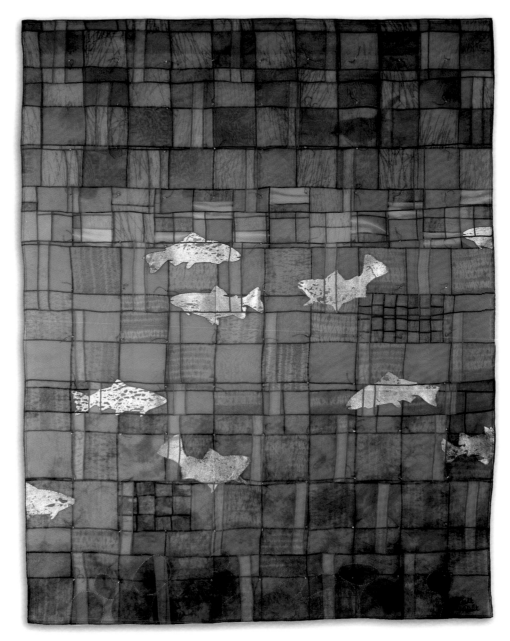

Silver Flash
52 x 40 inches

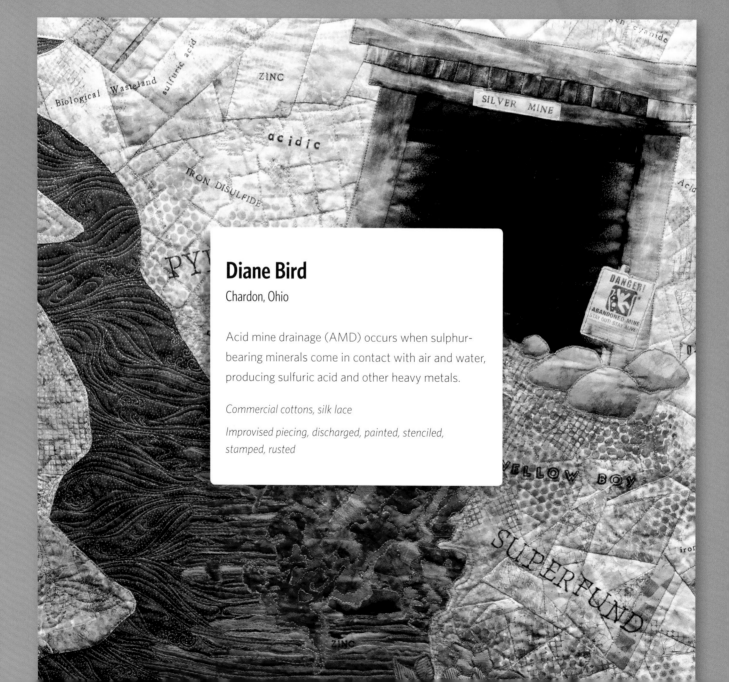

Diane Bird

Chardon, Ohio

Acid mine drainage (AMD) occurs when sulphur-bearing minerals come in contact with air and water, producing sulfuric acid and other heavy metals.

Commercial cottons, silk lace

Improvised piecing, discharged, painted, stenciled, stamped, rusted

A Mine is Forever
44 x 30 inches

Sandra Branjord

Sun City, Arizona

Susan G. Wooldridge writes about a woman rising from the depths of the night ocean: "You'll dream salty words that swim away sideways, slow." I celebrate this woman striving to rise and achieve her dreams, much as SAQA encourages the artist to rise and be the best she can be.

Cotton and synthetic fabric, glass, shell and metal beads, ink, bias tape, metal washers and sequins

Stamped, inked, burned, sponged, hand and machine appliquéd, machine pieced and quilted

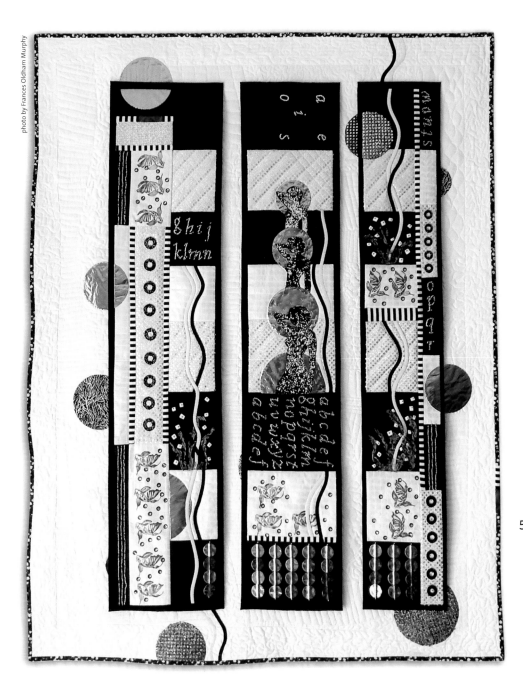

Still I Rise
50 x 39 inches

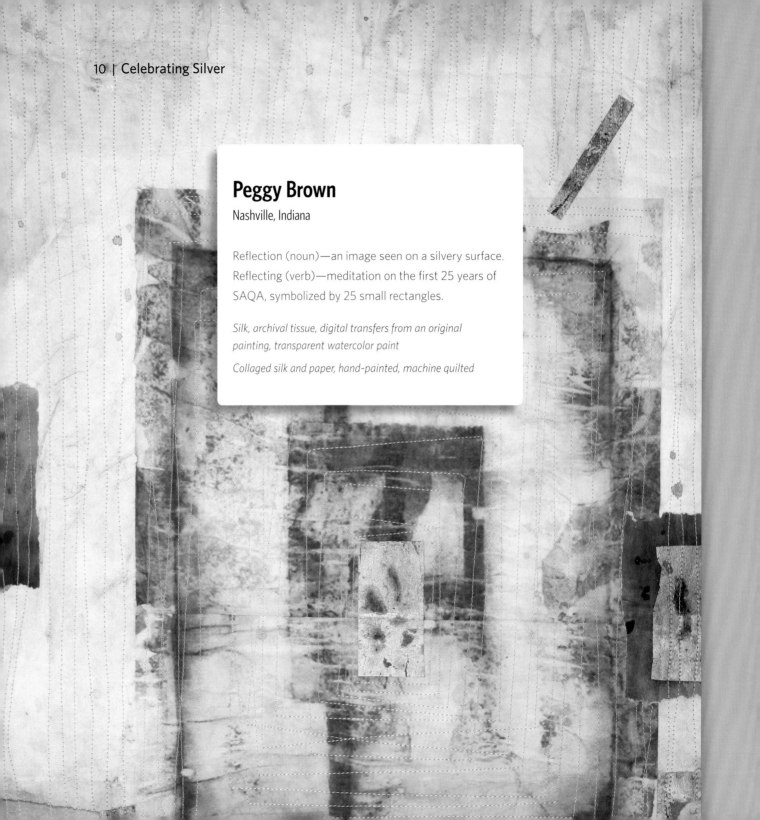

Peggy Brown

Nashville, Indiana

Reflection (noun)—an image seen on a silvery surface.
Reflecting (verb)—meditation on the first 25 years of
SAQA, symbolized by 25 small rectangles.

*Silk, archival tissue, digital transfers from an original
painting, transparent watercolor paint*

Collaged silk and paper, hand-painted, machine quilted

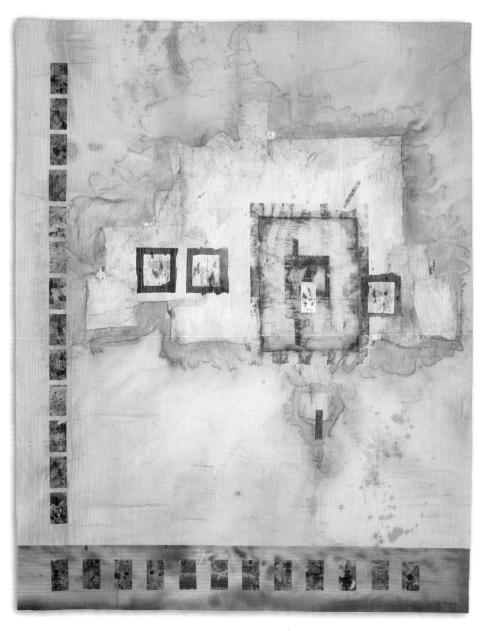

Reflections Reflecting
48 x 38 inches

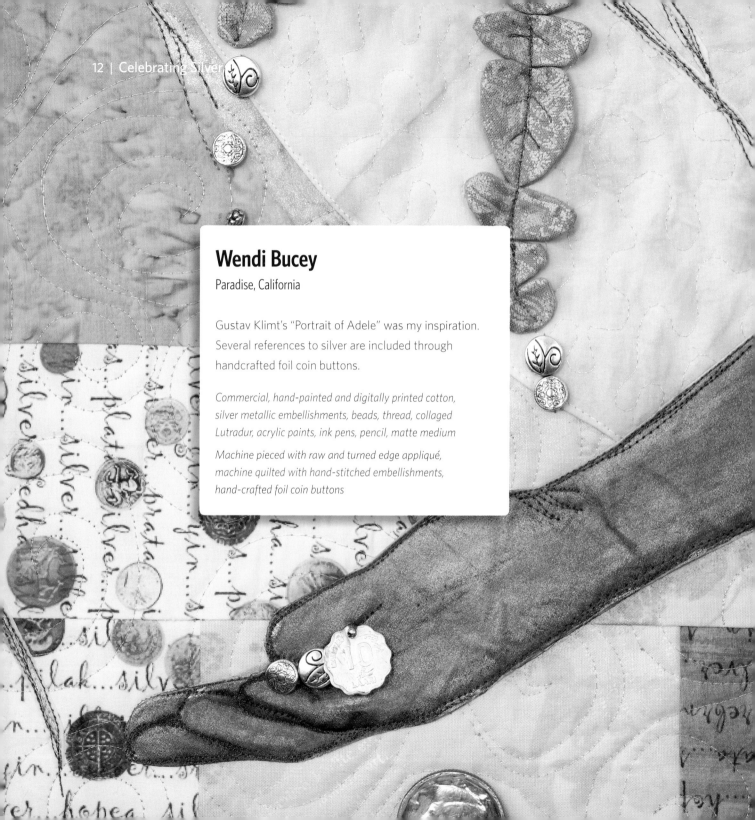

Wendi Bucey

Paradise, California

Gustav Klimt's "Portrait of Adele" was my inspiration. Several references to silver are included through handcrafted foil coin buttons.

Commercial, hand-painted and digitally printed cotton, silver metallic embellishments, beads, thread, collaged Lutradur, acrylic paints, ink pens, pencil, matte medium

Machine pieced with raw and turned edge appliqué, machine quilted with hand-stitched embellishments, hand-crafted foil coin buttons

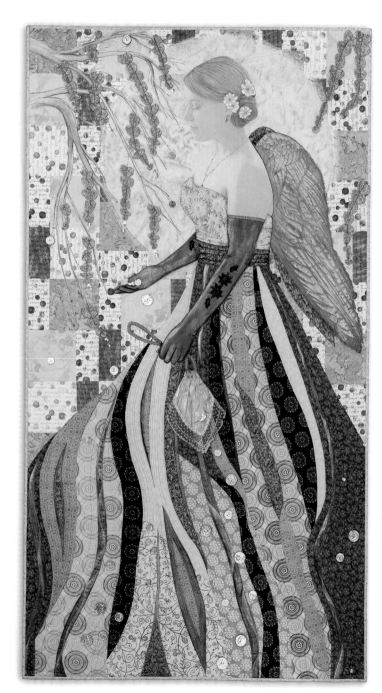

Angel of Silver
70 x 38 inches

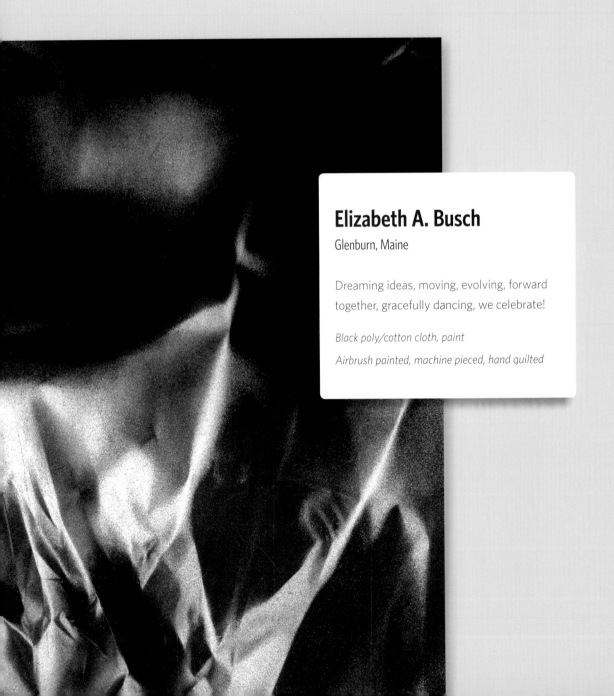

Elizabeth A. Busch

Glenburn, Maine

Dreaming ideas, moving, evolving, forward together, gracefully dancing, we celebrate!

Black poly/cotton cloth, paint
Airbrush painted, machine pieced, hand quilted

Dance With Me
47 x 31 inches

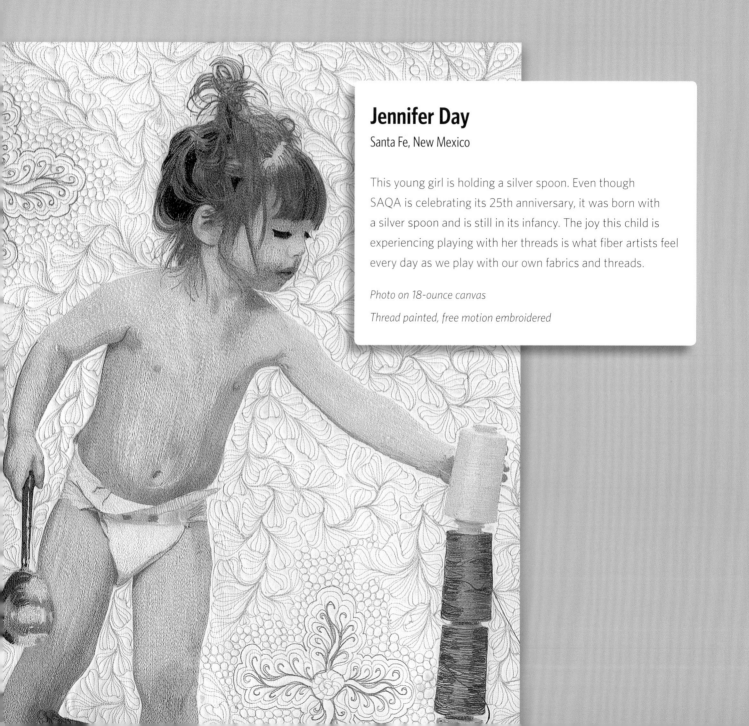

Jennifer Day

Santa Fe, New Mexico

This young girl is holding a silver spoon. Even though SAQA is celebrating its 25th anniversary, it was born with a silver spoon and is still in its infancy. The joy this child is experiencing playing with her threads is what fiber artists feel every day as we play with our own fabrics and threads.

Photo on 18-ounce canvas

Thread painted, free motion embroidered

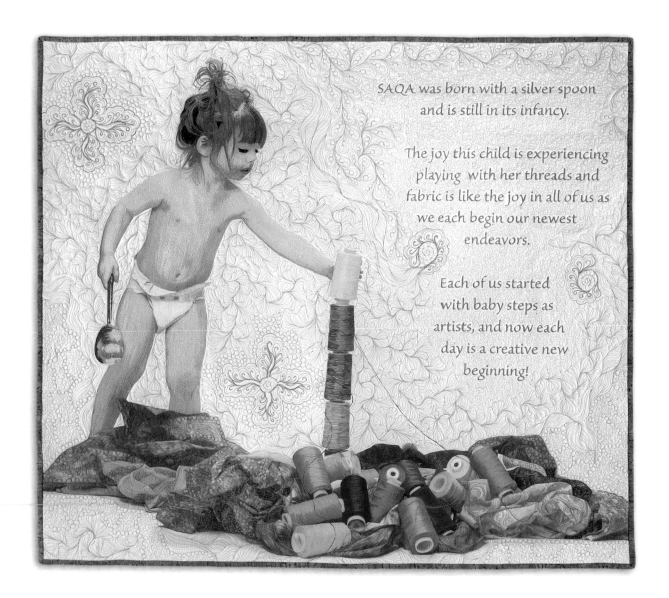

SAQA was born with a silver spoon and is still in its infancy.

The joy this child is experiencing playing with her threads and fabric is like the joy in all of us as we each begin our newest endeavors.

Each of us started with baby steps as artists, and now each day is a creative new beginning!

Beginnings
34 x 40 inches

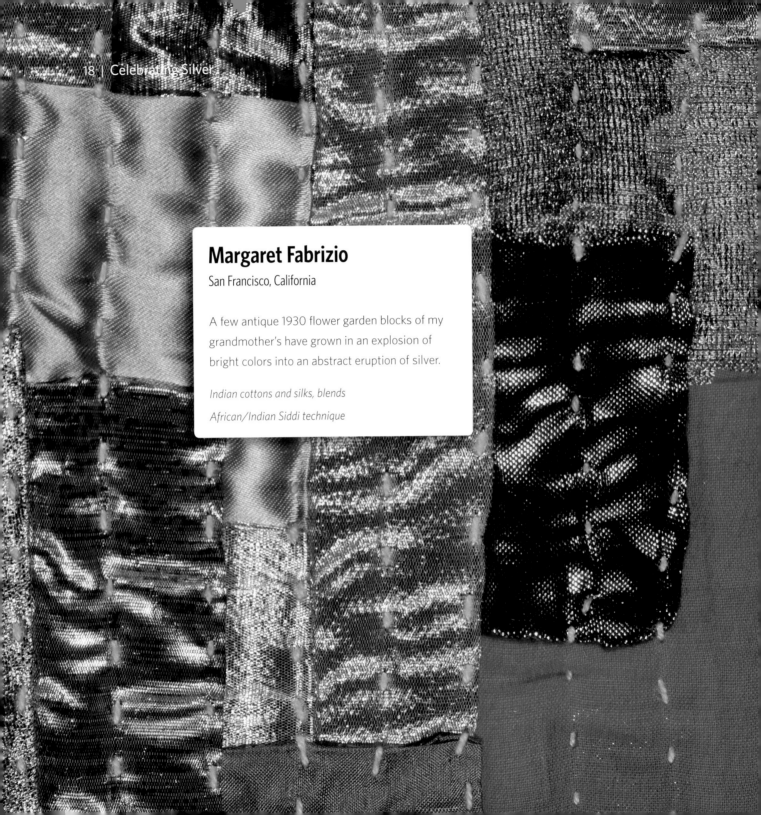

Margaret Fabrizio

San Francisco, California

A few antique 1930 flower garden blocks of my grandmother's have grown in an explosion of bright colors into an abstract eruption of silver.

Indian cottons and silks, blends

African/Indian Siddi technique

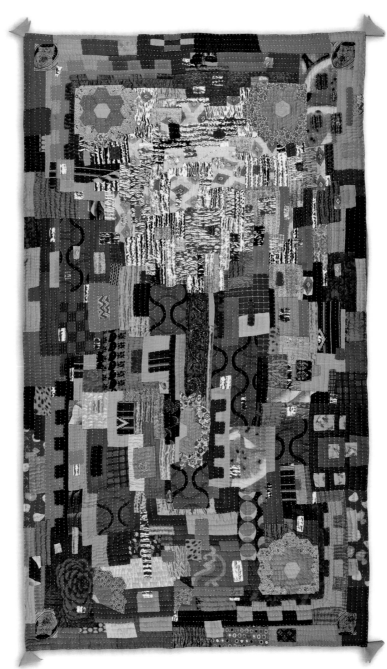

Silver Eruption
66 x 35 inches

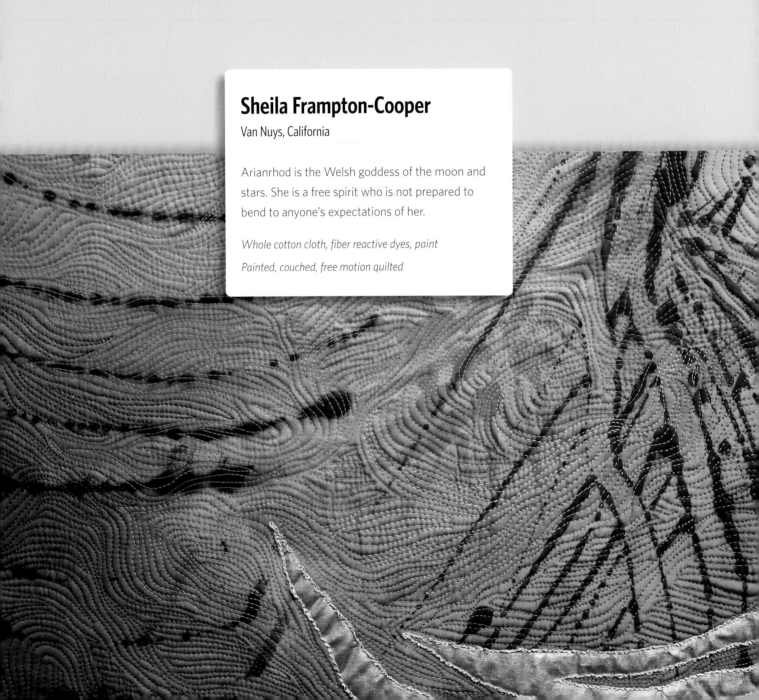

Sheila Frampton-Cooper

Van Nuys, California

Arianrhod is the Welsh goddess of the moon and stars. She is a free spirit who is not prepared to bend to anyone's expectations of her.

Whole cotton cloth, fiber reactive dyes, paint
Painted, couched, free motion quilted

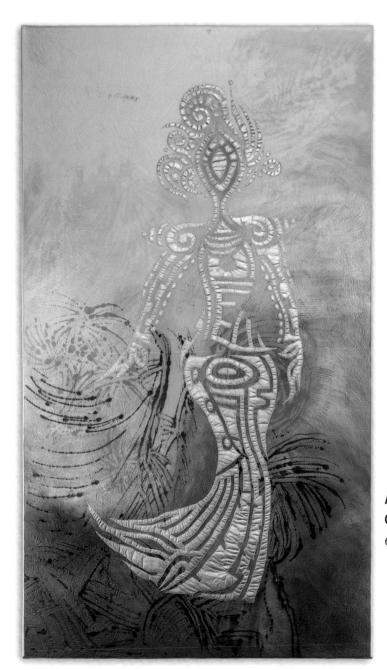

**Arianrhod-Goddess
of the Silver Wheel**

67 x 38 inches

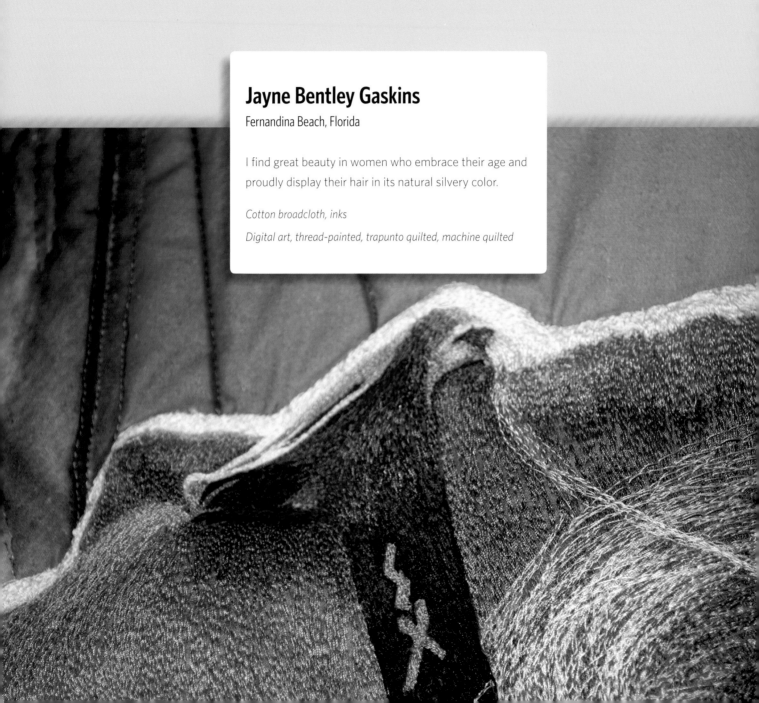

Jayne Bentley Gaskins

Fernandina Beach, Florida

I find great beauty in women who embrace their age and proudly display their hair in its natural silvery color.

Cotton broadcloth, inks

Digital art, thread-painted, trapunto quilted, machine quilted

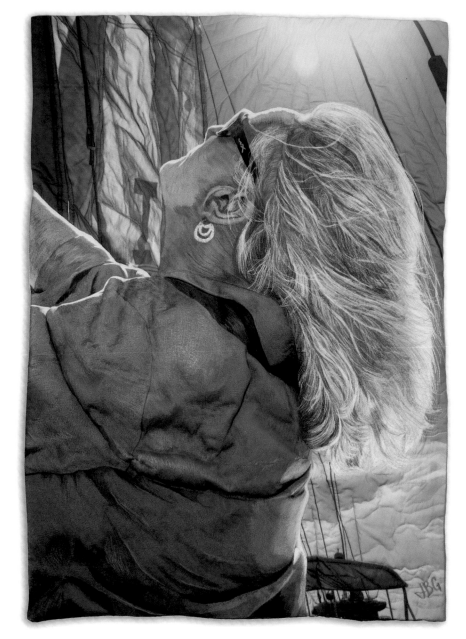

Embracing the Silver Years
46 x 32 inches

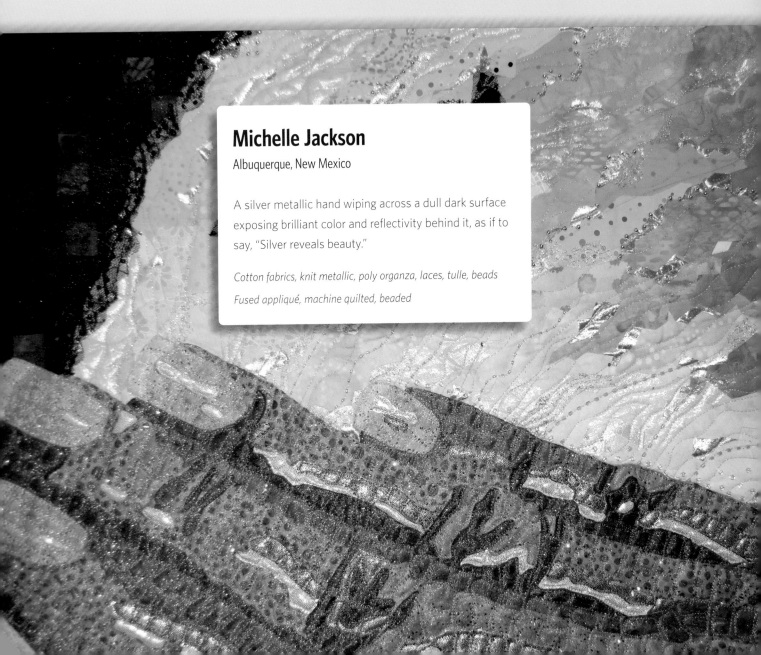

Michelle Jackson

Albuquerque, New Mexico

A silver metallic hand wiping across a dull dark surface exposing brilliant color and reflectivity behind it, as if to say, "Silver reveals beauty."

Cotton fabrics, knit metallic, poly organza, laces, tulle, beads
Fused appliqué, machine quilted, beaded

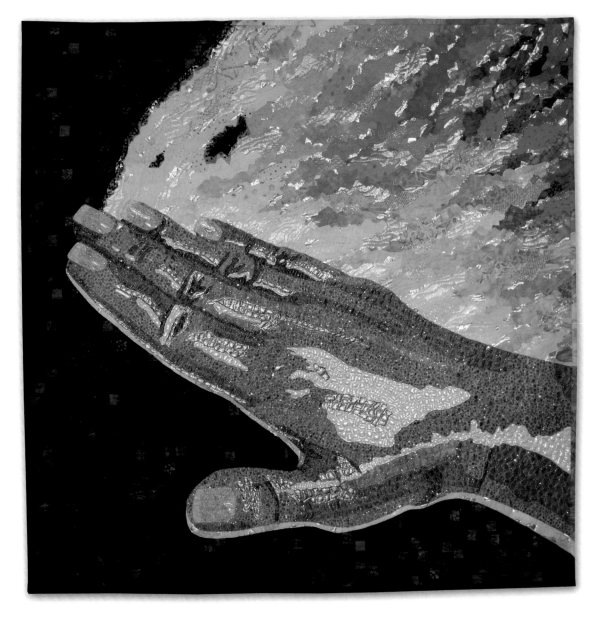

The Silver Touch
40 x 40 inches

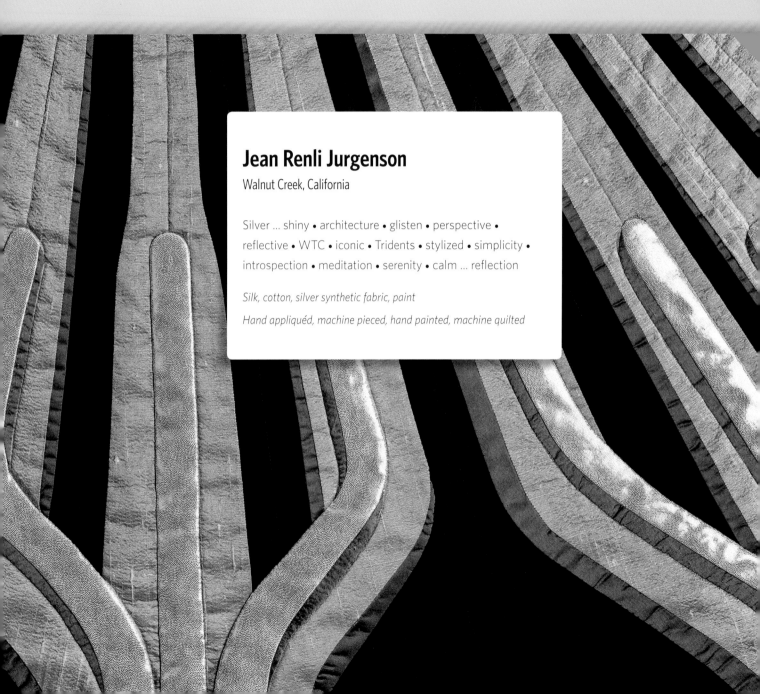

Jean Renli Jurgenson

Walnut Creek, California

Silver ... shiny • architecture • glisten • perspective • reflective • WTC • iconic • Tridents • stylized • simplicity • introspection • meditation • serenity • calm ... reflection

Silk, cotton, silver synthetic fabric, paint

Hand appliquéd, machine pieced, hand painted, machine quilted

Reflection — World Trade Center
50 x 35 inches

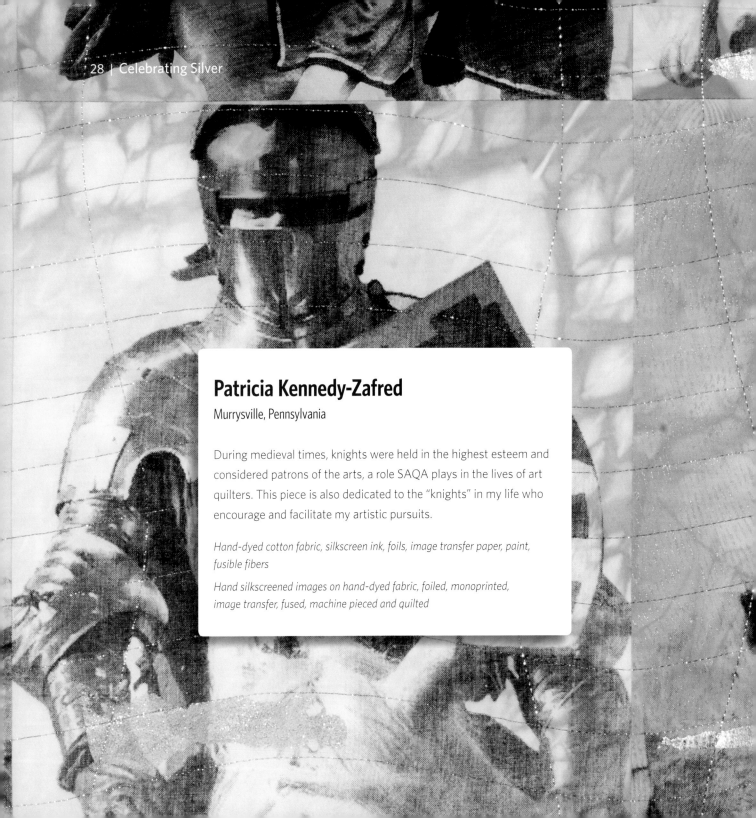

Patricia Kennedy-Zafred

Murrysville, Pennsylvania

During medieval times, knights were held in the highest esteem and considered patrons of the arts, a role SAQA plays in the lives of art quilters. This piece is also dedicated to the "knights" in my life who encourage and facilitate my artistic pursuits.

Hand-dyed cotton fabric, silkscreen ink, foils, image transfer paper, paint, fusible fibers

Hand silkscreened images on hand-dyed fabric, foiled, monoprinted, image transfer, fused, machine pieced and quilted

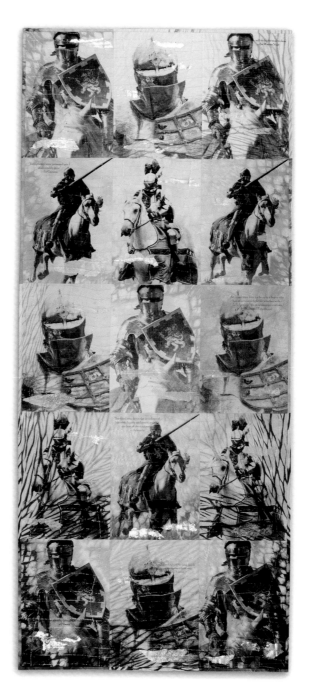

On That Silver Knight
70 x 30 inches

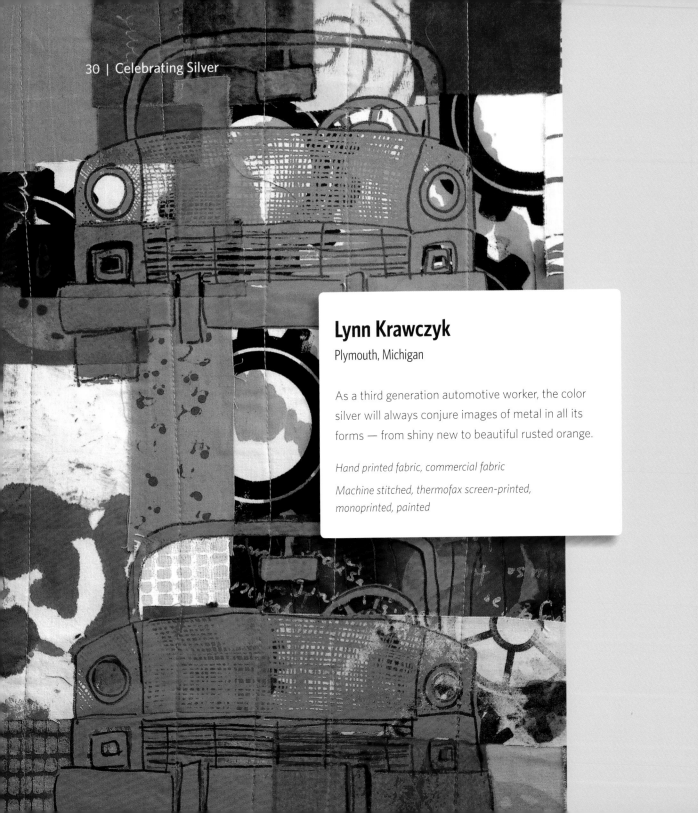

Lynn Krawczyk

Plymouth, Michigan

As a third generation automotive worker, the color silver will always conjure images of metal in all its forms — from shiny new to beautiful rusted orange.

Hand printed fabric, commercial fabric

Machine stitched, thermofax screen-printed, monoprinted, painted

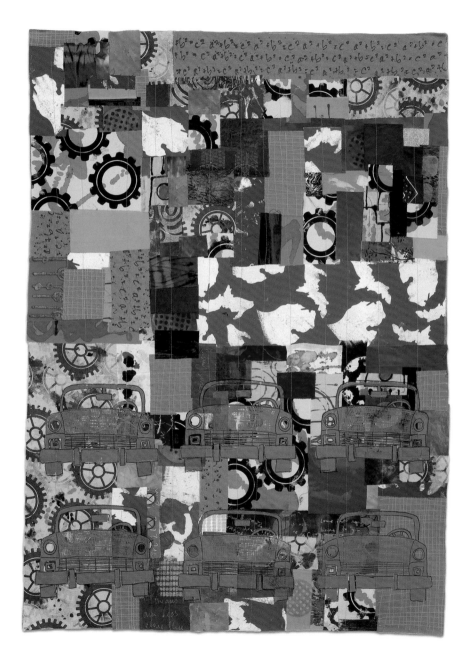

Rusted Silver
44 x 32 inches

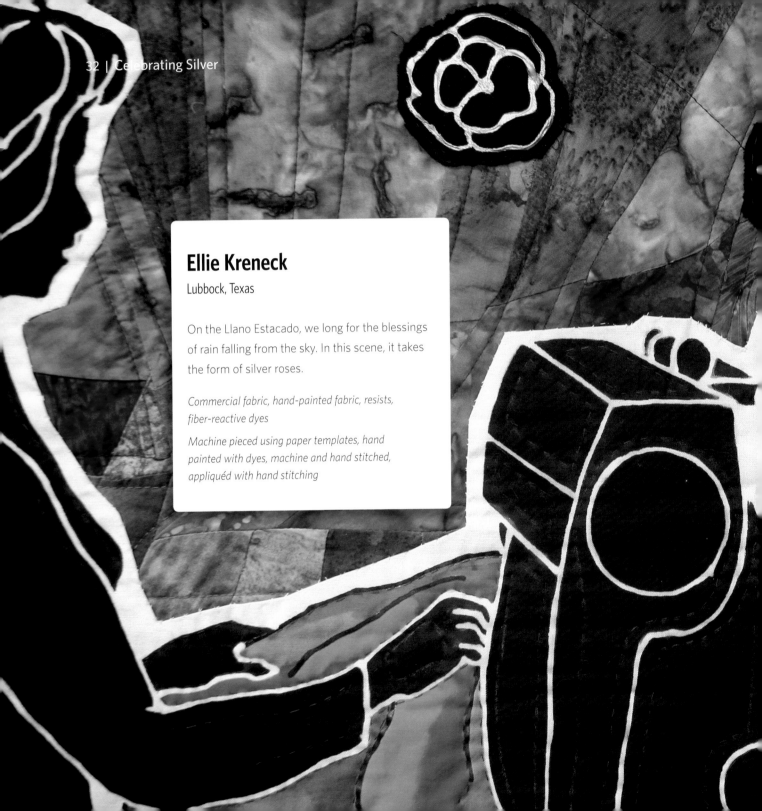

Ellie Kreneck

Lubbock, Texas

On the Llano Estacado, we long for the blessings of rain falling from the sky. In this scene, it takes the form of silver roses.

Commercial fabric, hand-painted fabric, resists, fiber-reactive dyes

Machine pieced using paper templates, hand painted with dyes, machine and hand stitched, appliquéd with hand stitching

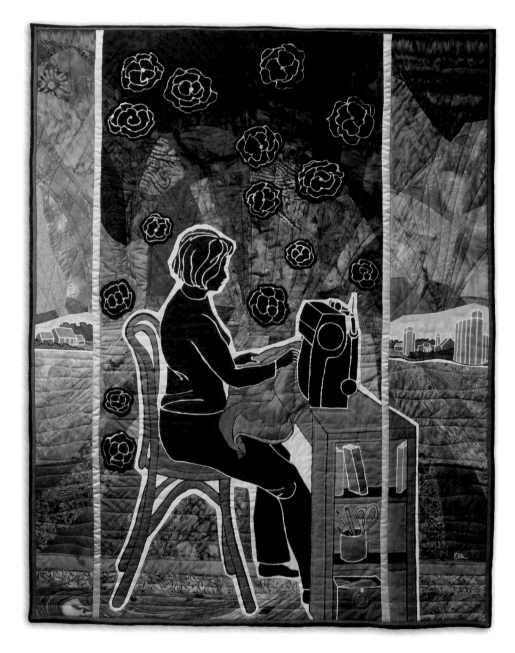

Silver Roses Fall on the Llano

49 x 39 inches

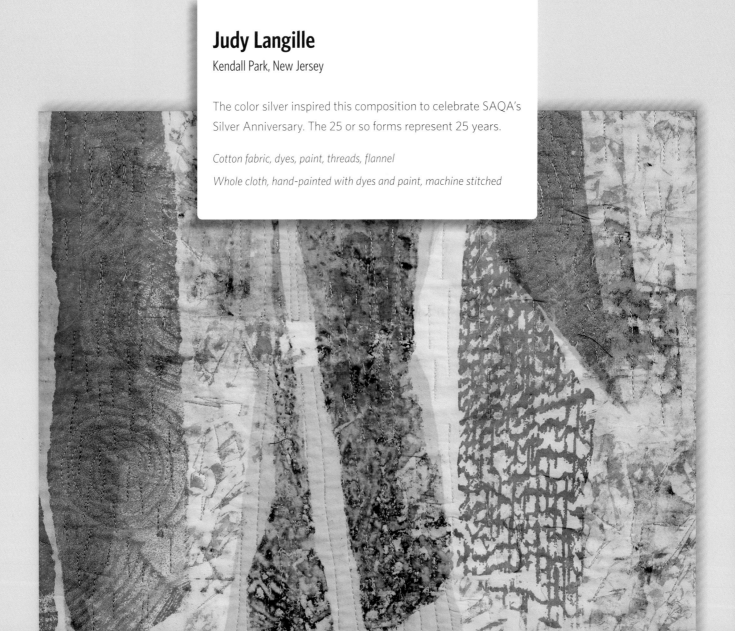

Judy Langille
Kendall Park, New Jersey

The color silver inspired this composition to celebrate SAQA's Silver Anniversary. The 25 or so forms represent 25 years.

Cotton fabric, dyes, paint, threads, flannel

Whole cloth, hand-painted with dyes and paint, machine stitched

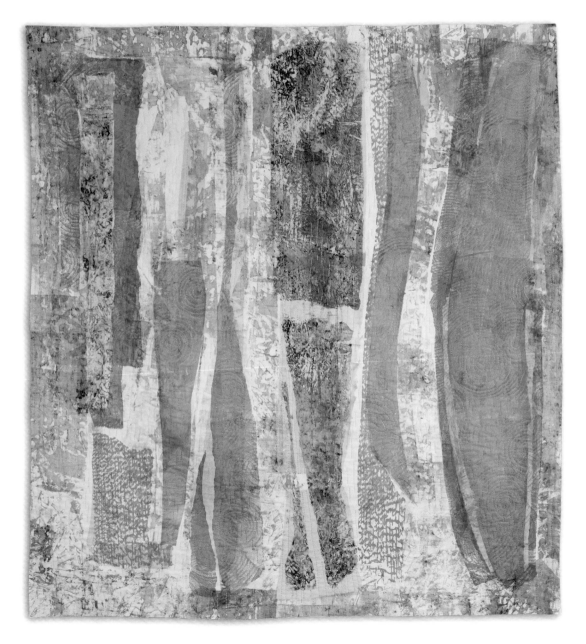

Silver Forms
42 x 40 inches

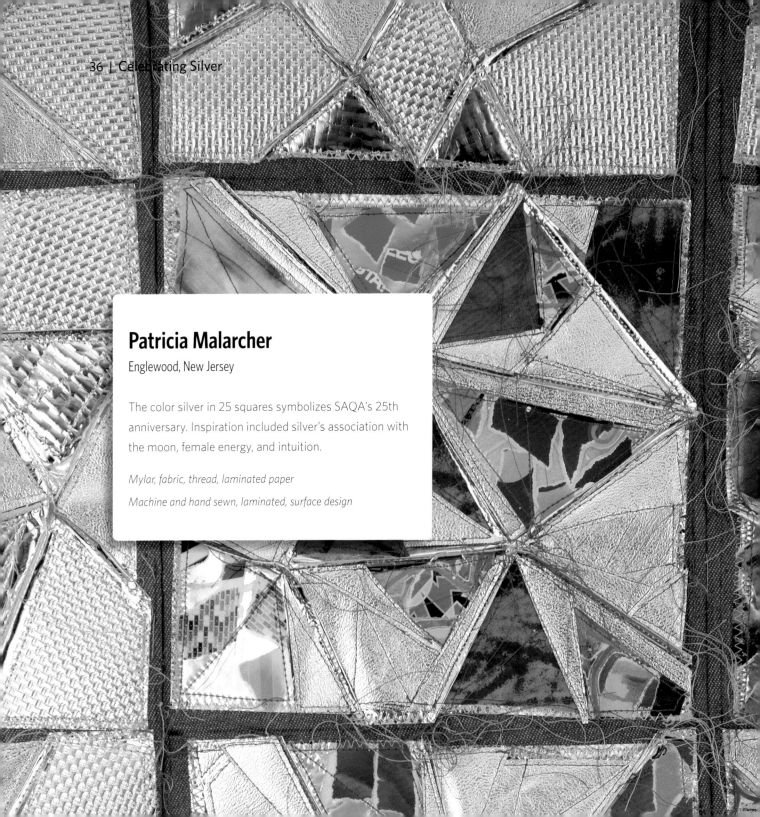

Patricia Malarcher

Englewood, New Jersey

The color silver in 25 squares symbolizes SAQA's 25th anniversary. Inspiration included silver's association with the moon, female energy, and intuition.

Mylar, fabric, thread, laminated paper

Machine and hand sewn, laminated, surface design

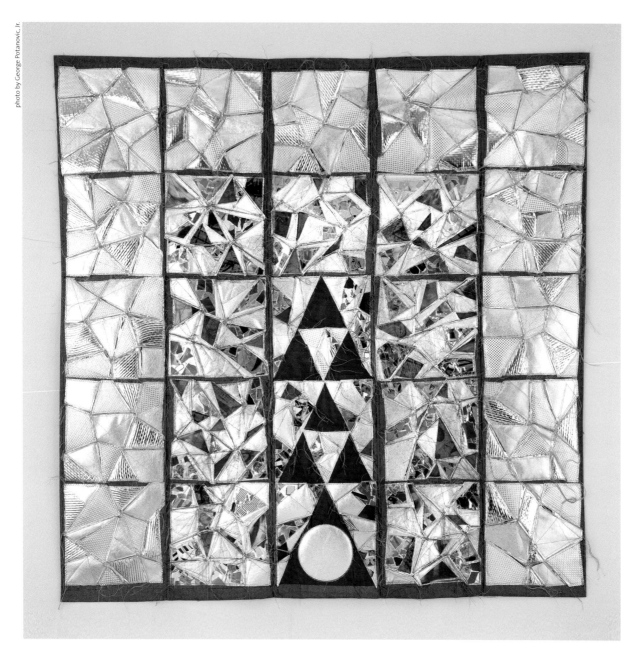

Lunar Portal
40 x 40 inches

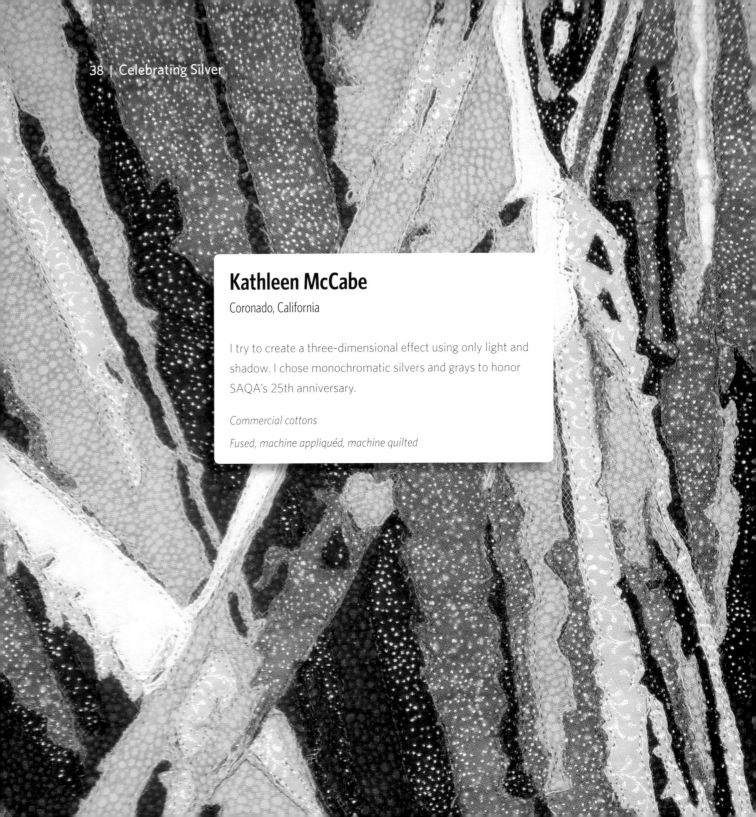

Kathleen McCabe

Coronado, California

I try to create a three-dimensional effect using only light and shadow. I chose monochromatic silvers and grays to honor SAQA's 25th anniversary.

Commercial cottons

Fused, machine appliquéd, machine quilted

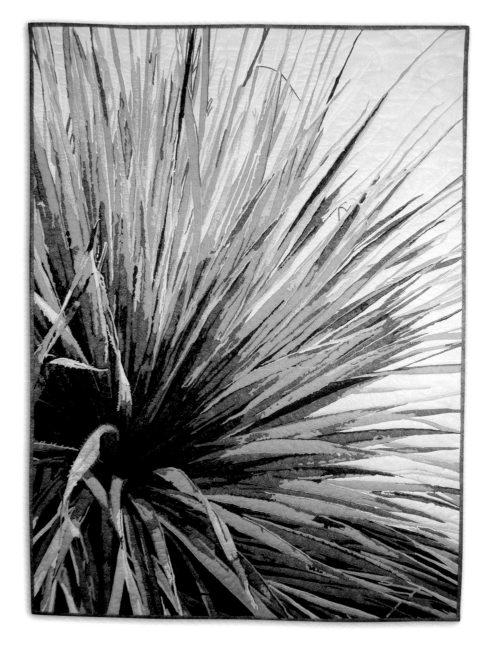

Jubilation

57 x 40 inches

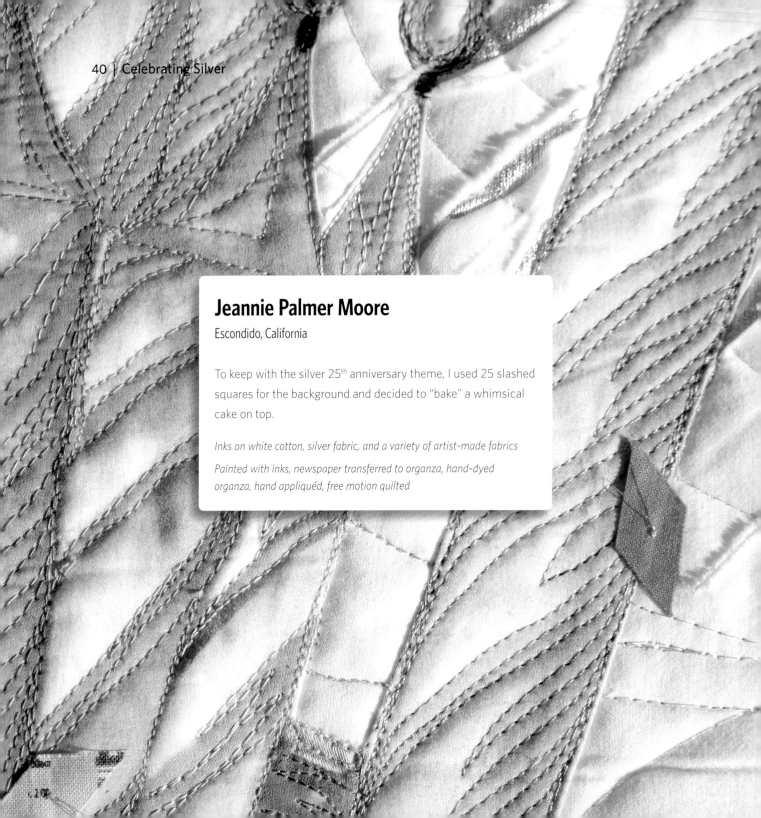

Jeannie Palmer Moore

Escondido, California

To keep with the silver 25th anniversary theme, I used 25 slashed squares for the background and decided to "bake" a whimsical cake on top.

Inks on white cotton, silver fabric, and a variety of artist-made fabrics

Painted with inks, newspaper transferred to organza, hand-dyed organza, hand appliquéd, free motion quilted

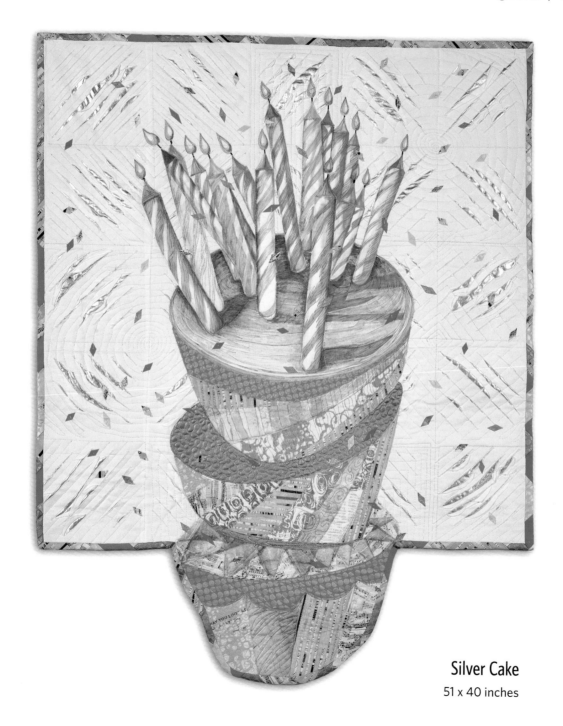

Silver Cake
51 x 40 inches

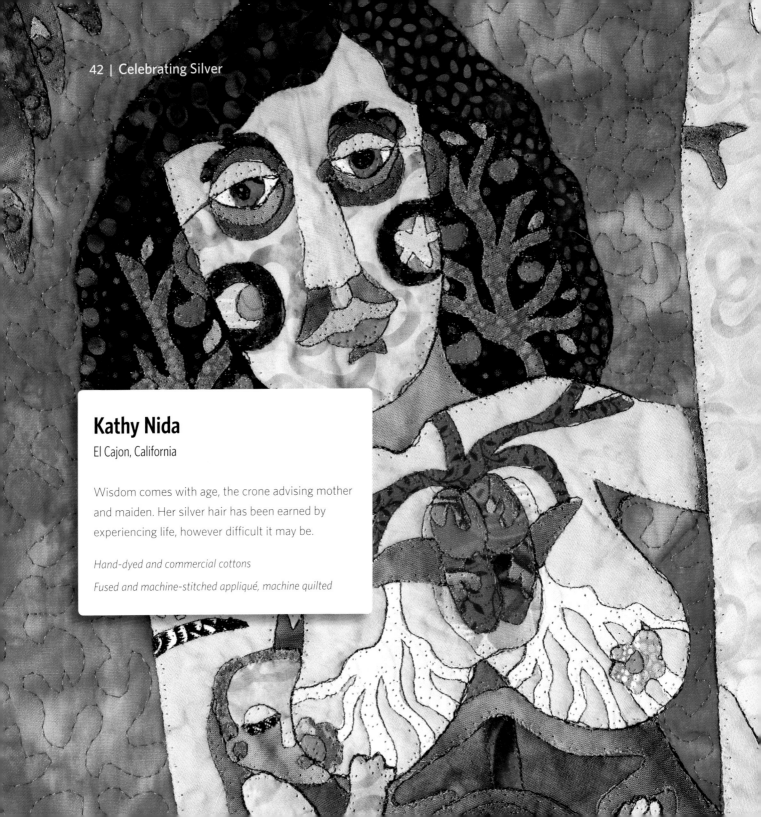

Kathy Nida

El Cajon, California

Wisdom comes with age, the crone advising mother and maiden. Her silver hair has been earned by experiencing life, however difficult it may be.

Hand-dyed and commercial cottons
Fused and machine-stitched appliqué, machine quilted

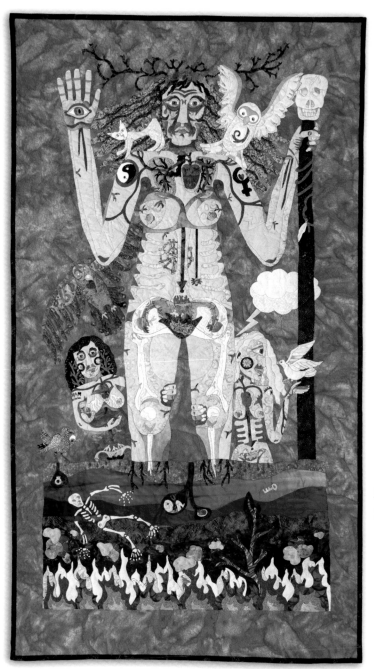

Awakening the Crone
70 x 40 inches

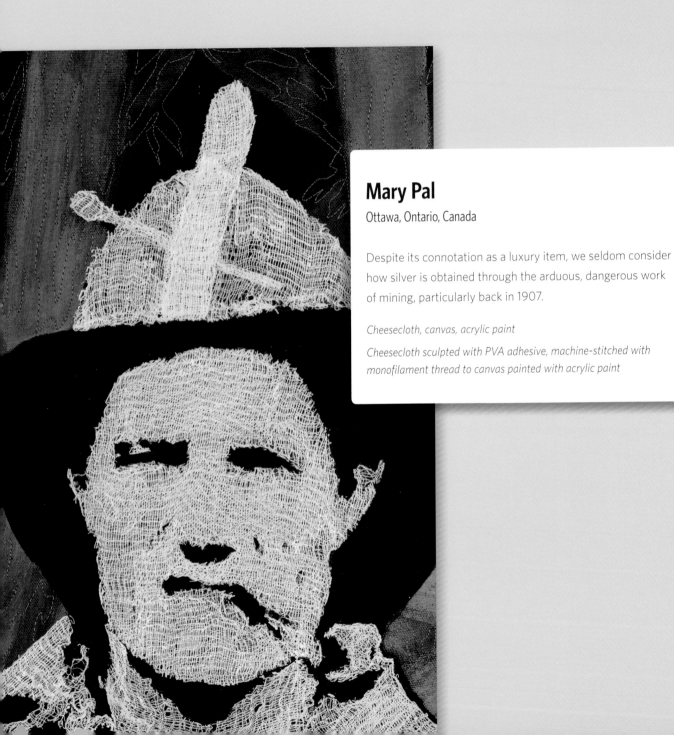

Mary Pal
Ottawa, Ontario, Canada

Despite its connotation as a luxury item, we seldom consider how silver is obtained through the arduous, dangerous work of mining, particularly back in 1907.

Cheesecloth, canvas, acrylic paint
Cheesecloth sculpted with PVA adhesive, machine-stitched with monofilament thread to canvas painted with acrylic paint

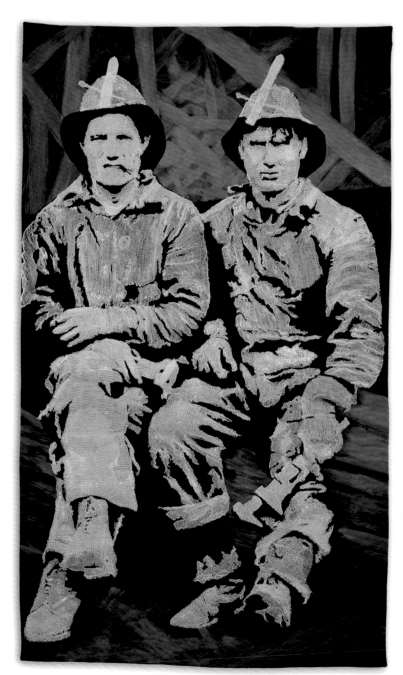

Precious Time
60 x 36 inches

Sandra Poteet

Grass Valley, California

My birch grove presents two forms of silver: the precious grayish-white metal element with atomic number 47 and nature's remarkable gray-white trees.

Paint on batting, sheers, synthetics, ink

Photo printed on fabric, painted, paper laminated, silk screened

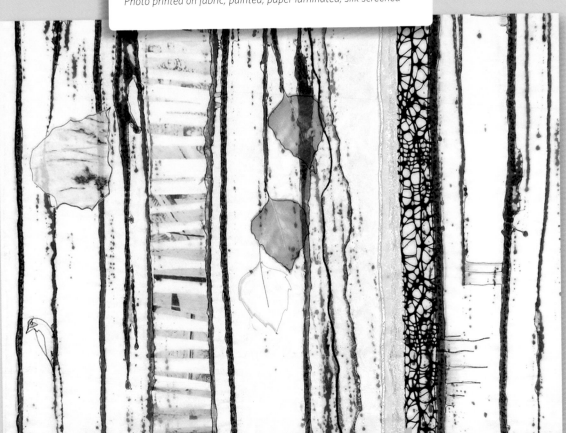

Silver Birch Grove
70 x 40 inches

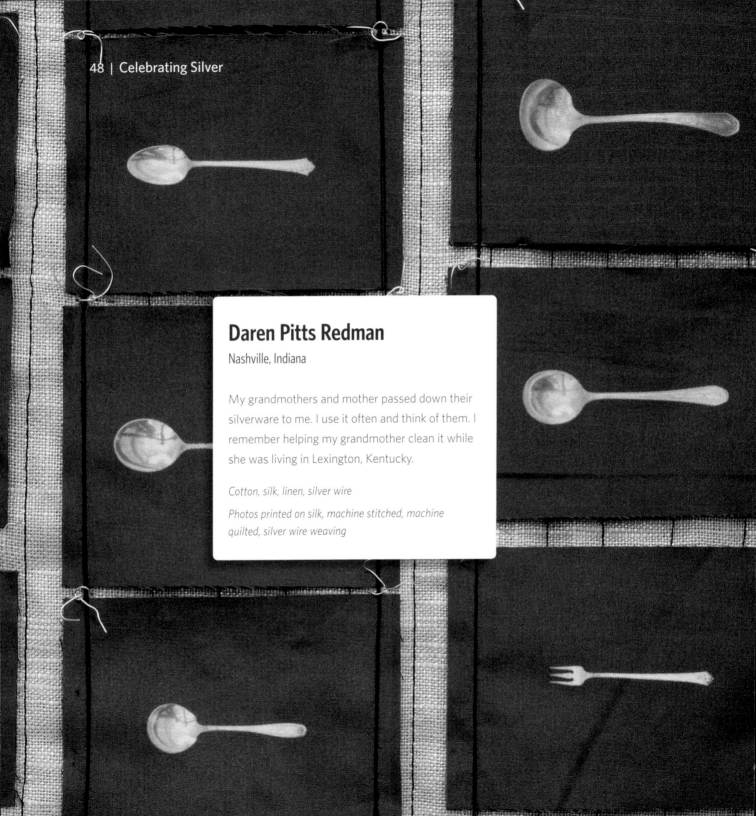

Daren Pitts Redman

Nashville, Indiana

My grandmothers and mother passed down their silverware to me. I use it often and think of them. I remember helping my grandmother clean it while she was living in Lexington, Kentucky.

Cotton, silk, linen, silver wire
Photos printed on silk, machine stitched, machine quilted, silver wire weaving

Silver Legacy
62 x 36 inches

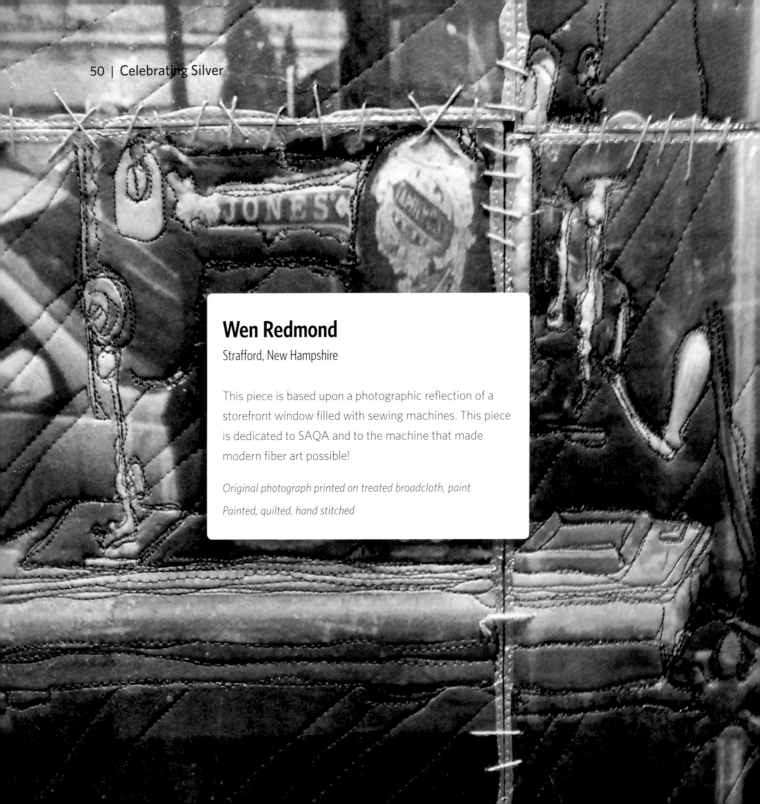

Wen Redmond

Strafford, New Hampshire

This piece is based upon a photographic reflection of a storefront window filled with sewing machines. This piece is dedicated to SAQA and to the machine that made modern fiber art possible!

Original photograph printed on treated broadcloth, paint

Painted, quilted, hand stitched

The Machine
45 x 43 inches

Joan Schulze

Sunnyvale, California

Inspiration came from a quote by Andy Warhol: "Silver was the future, it was spacey... silver was also the past — the Silver Screen."

Cotton, silk, paper
Monoprinted, glue transfer process, pieced, machine quilted

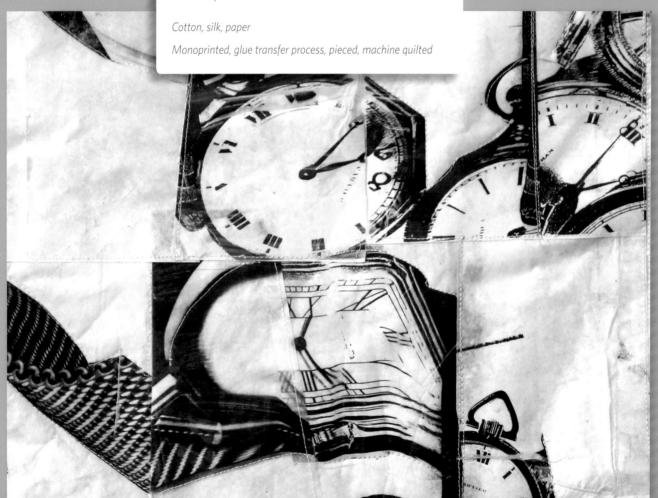

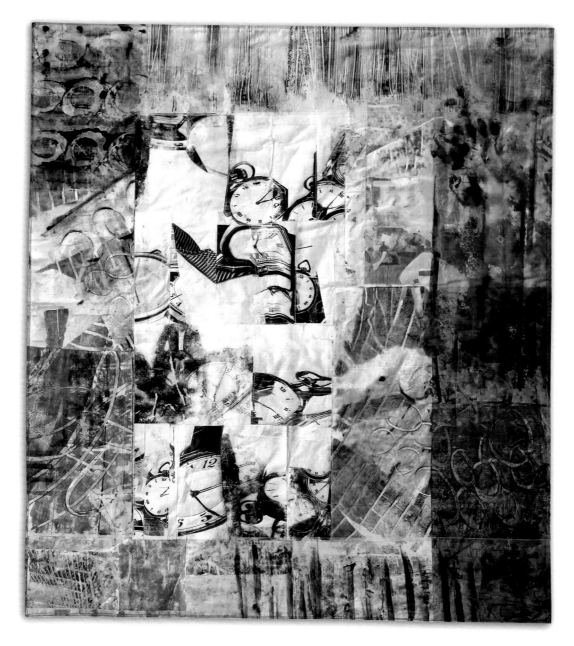

Past & Future
43 x 40 inches

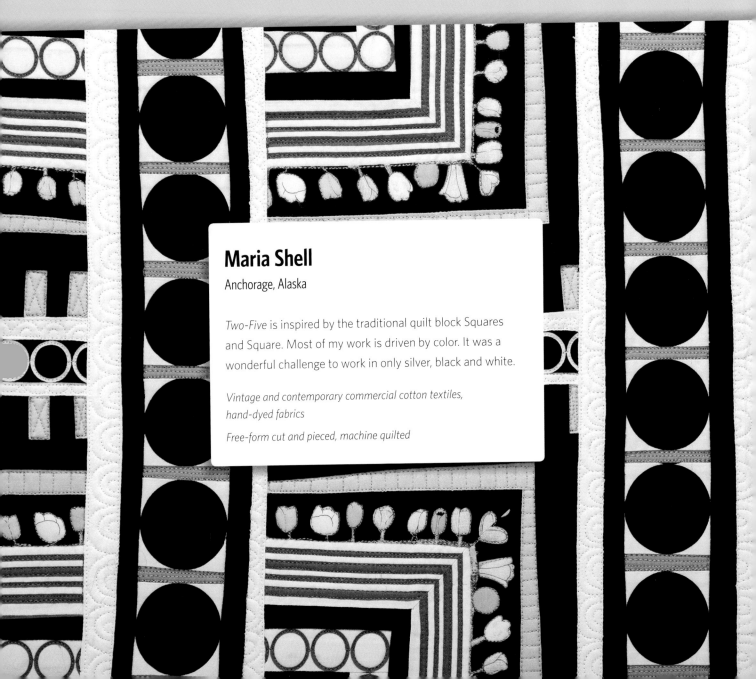

Maria Shell

Anchorage, Alaska

Two-Five is inspired by the traditional quilt block Squares and Square. Most of my work is driven by color. It was a wonderful challenge to work in only silver, black and white.

Vintage and contemporary commercial cotton textiles, hand-dyed fabrics

Free-form cut and pieced, machine quilted

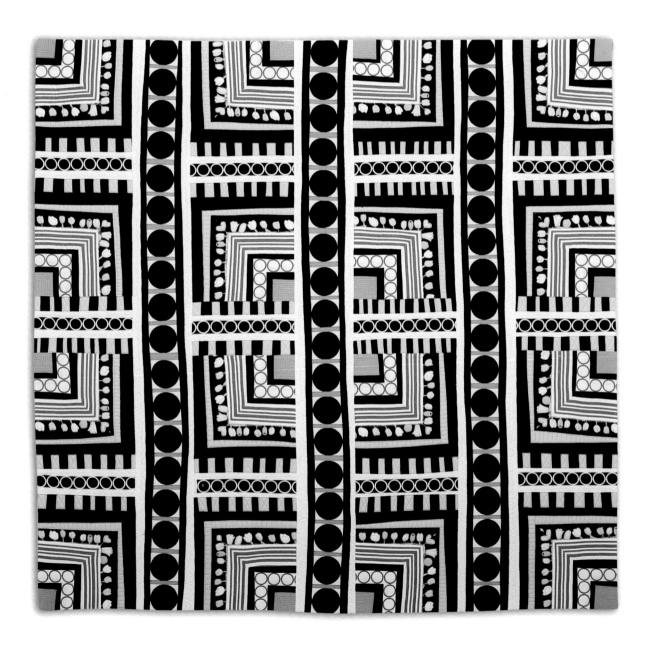

Two-Five
38 x 38 inches

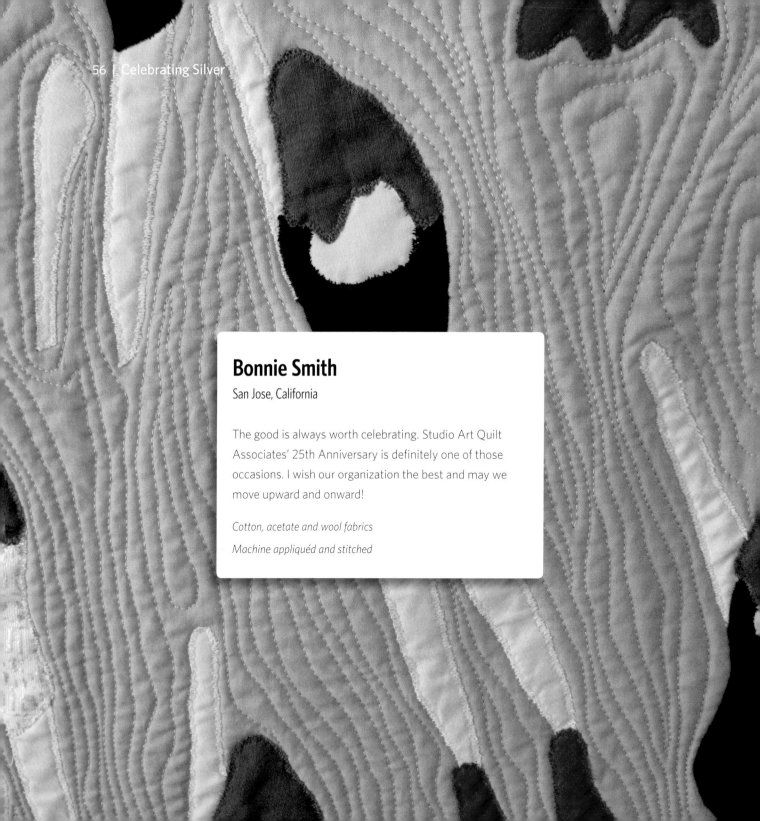

Bonnie Smith

San Jose, California

The good is always worth celebrating. Studio Art Quilt Associates' 25th Anniversary is definitely one of those occasions. I wish our organization the best and may we move upward and onward!

Cotton, acetate and wool fabrics
Machine appliquéd and stitched

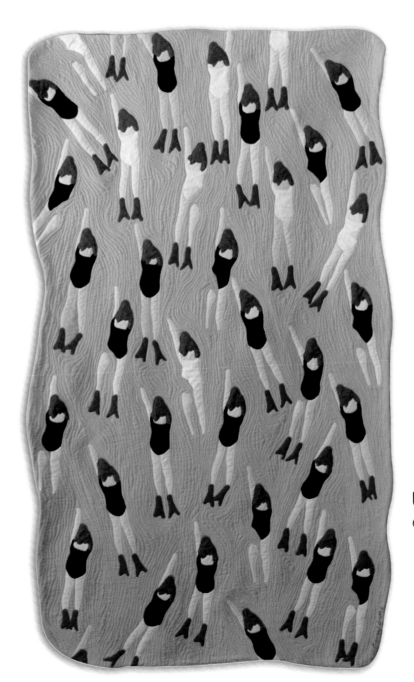

Upward and Onward

67 x 35 inches

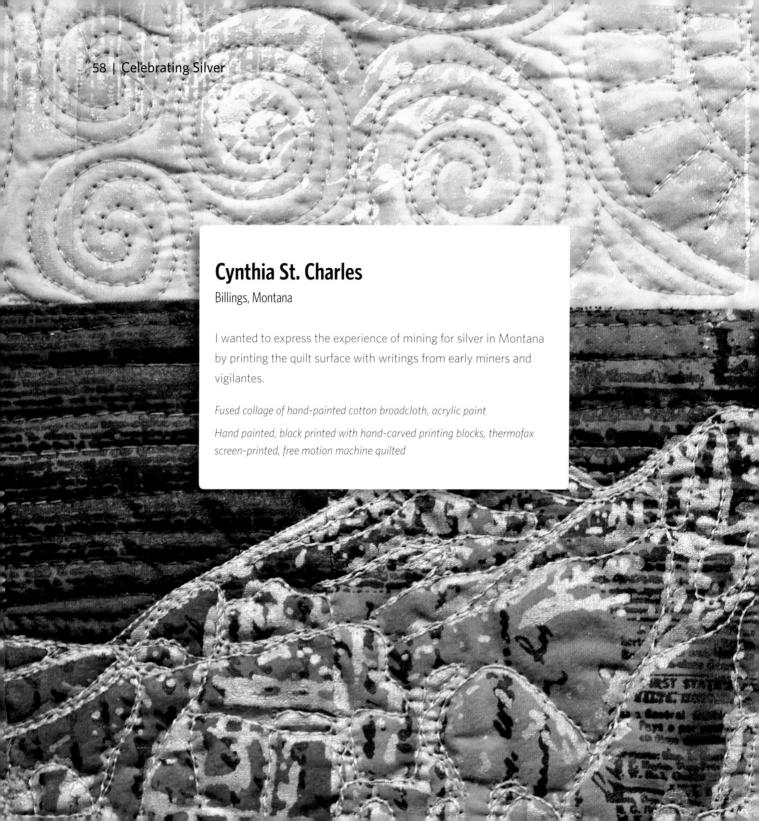

Cynthia St. Charles

Billings, Montana

I wanted to express the experience of mining for silver in Montana by printing the quilt surface with writings from early miners and vigilantes.

Fused collage of hand-painted cotton broadcloth, acrylic paint

Hand painted, block printed with hand-carved printing blocks, thermofax screen-printed, free motion machine quilted

Silver Hills
64 x 39 inches

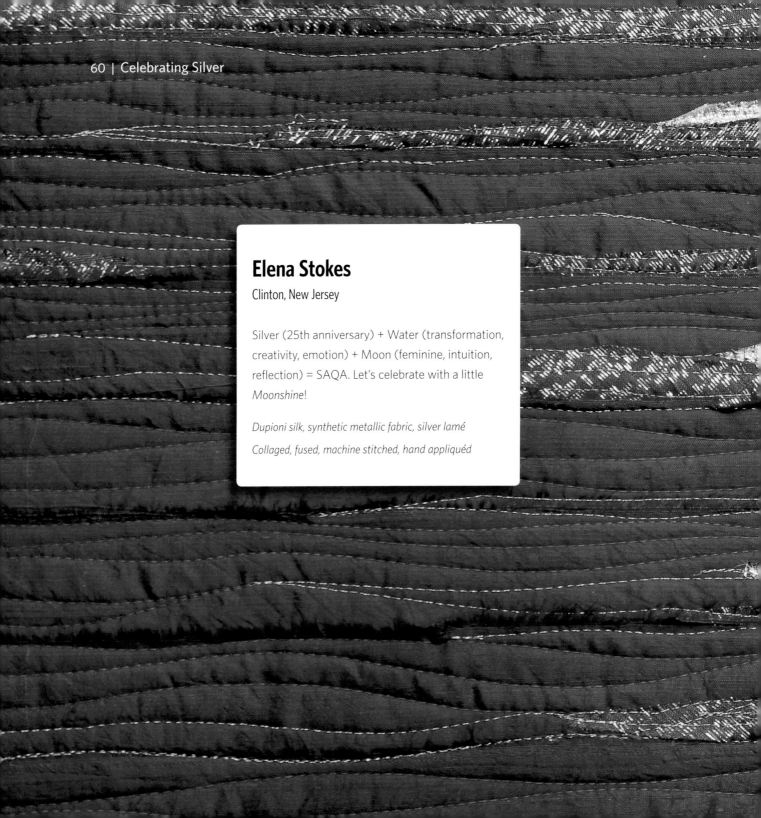

Elena Stokes

Clinton, New Jersey

Silver (25th anniversary) + Water (transformation, creativity, emotion) + Moon (feminine, intuition, reflection) = SAQA. Let's celebrate with a little *Moonshine*!

Dupioni silk, synthetic metallic fabric, silver lamé
Collaged, fused, machine stitched, hand appliquéd

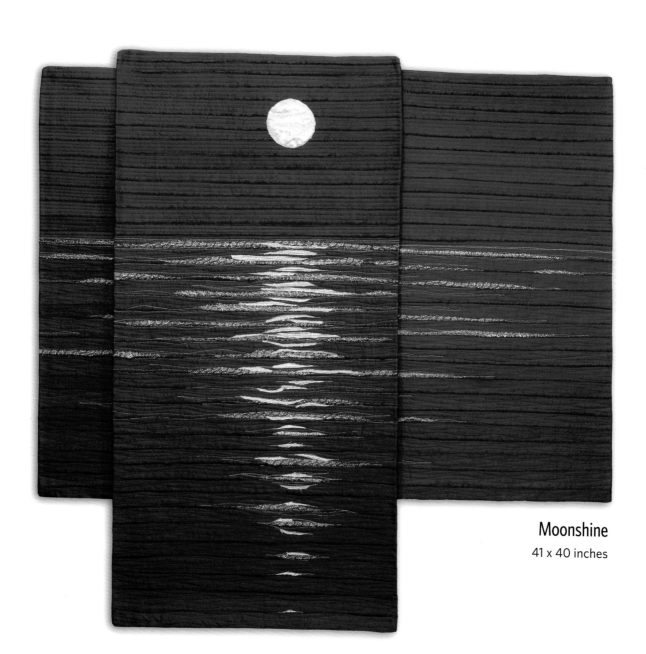

Moonshine
41 x 40 inches

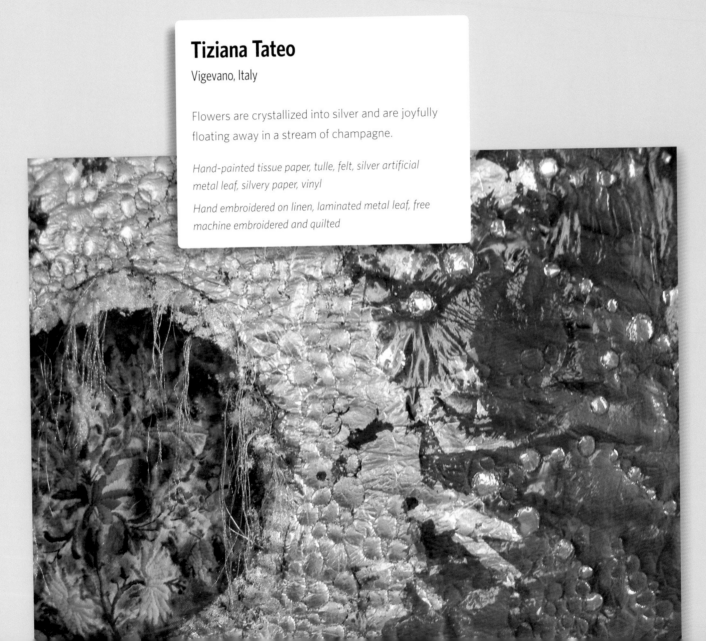

Tiziana Tateo

Vigevano, Italy

Flowers are crystallized into silver and are joyfully floating away in a stream of champagne.

Hand-painted tissue paper, tulle, felt, silver artificial metal leaf, silvery paper, vinyl

Hand embroidered on linen, laminated metal leaf, free machine embroidered and quilted

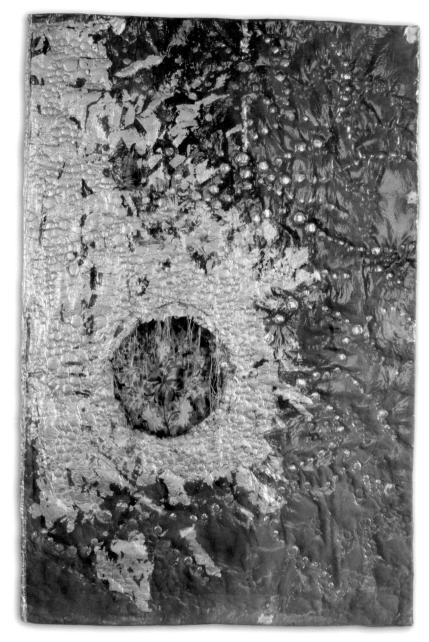

Flowers and Champagne Streams
55 x 37 inches

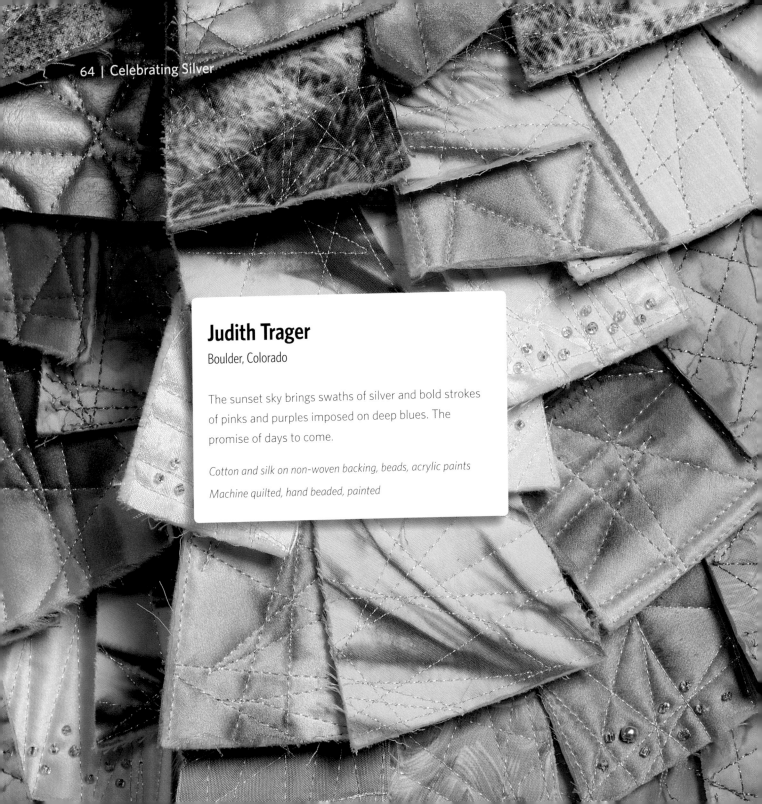

Judith Trager

Boulder, Colorado

The sunset sky brings swaths of silver and bold strokes of pinks and purples imposed on deep blues. The promise of days to come.

Cotton and silk on non-woven backing, beads, acrylic paints
Machine quilted, hand beaded, painted

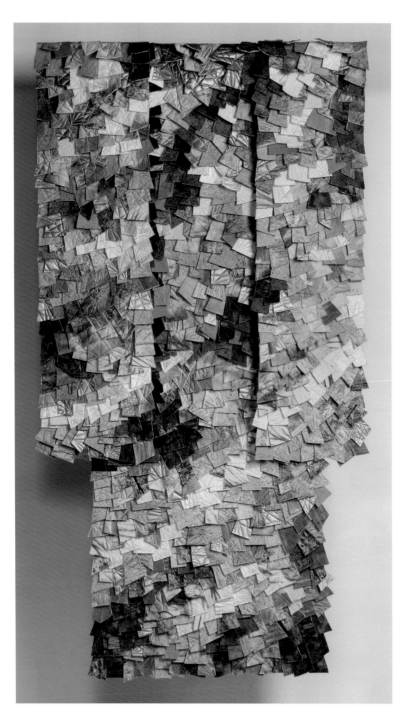

Ciel D'Argent
70 x 40 inches

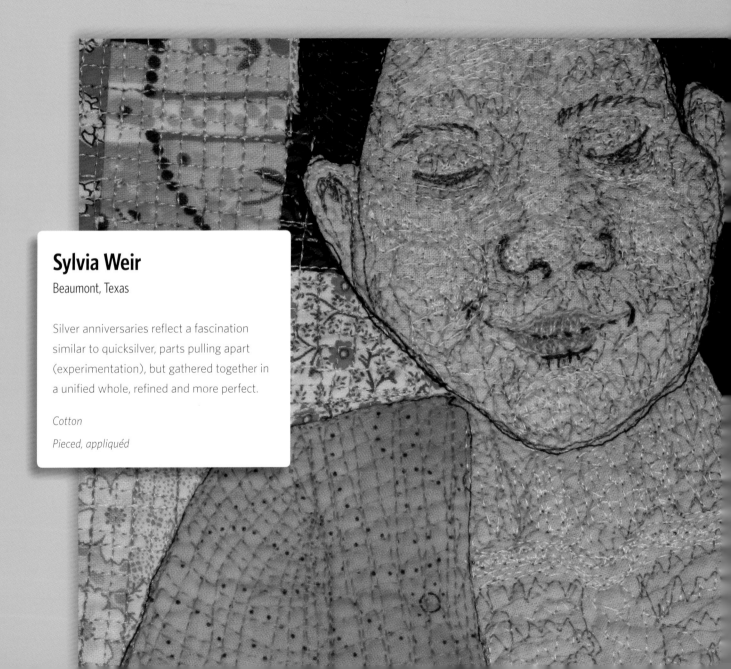

Sylvia Weir

Beaumont, Texas

Silver anniversaries reflect a fascination similar to quicksilver, parts pulling apart (experimentation), but gathered together in a unified whole, refined and more perfect.

Cotton

Pieced, appliquéd

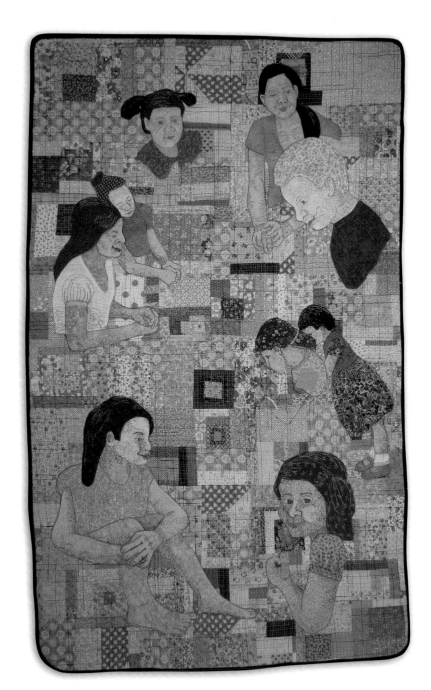

Quicksilver
59 x 35 inches

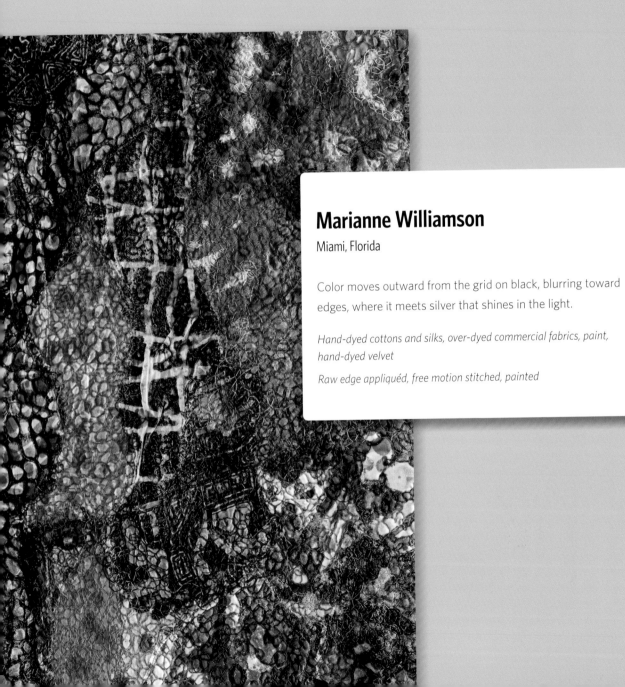

Marianne Williamson

Miami, Florida

Color moves outward from the grid on black, blurring toward edges, where it meets silver that shines in the light.

Hand-dyed cottons and silks, over-dyed commercial fabrics, paint, hand-dyed velvet

Raw edge appliquéd, free motion stitched, painted

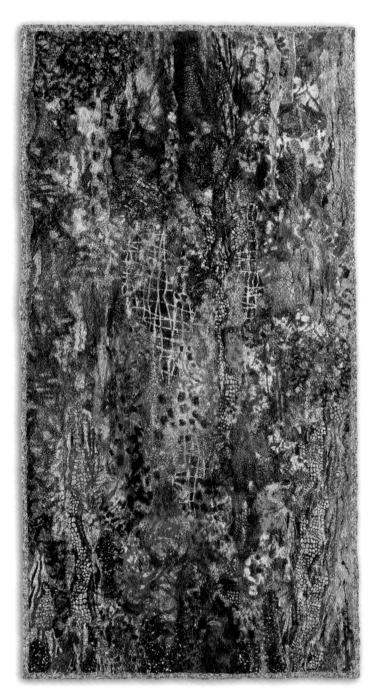

Silver Abstractions

69 x 37 inches

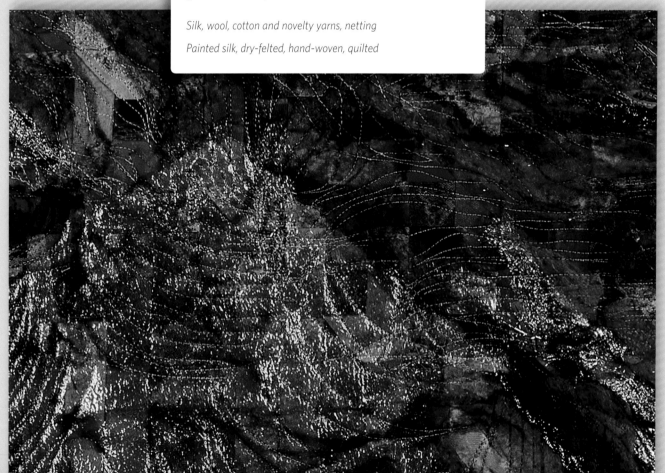

Rosaline M. Young

Cape Coral, Florida

I am inspired by 25 years of QUILTS moving from the bed onto the wall, passing that exuberance on to future generations of quilters.

Silk, wool, cotton and novelty yarns, netting

Painted silk, dry-felted, hand-woven, quilted

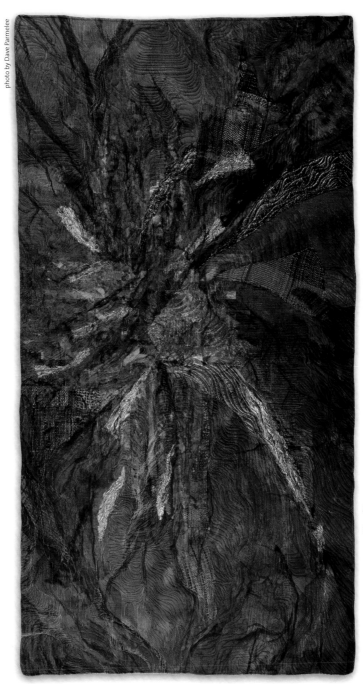

photo by Dave Parmelee

Art Quilt
65 x 34 inches

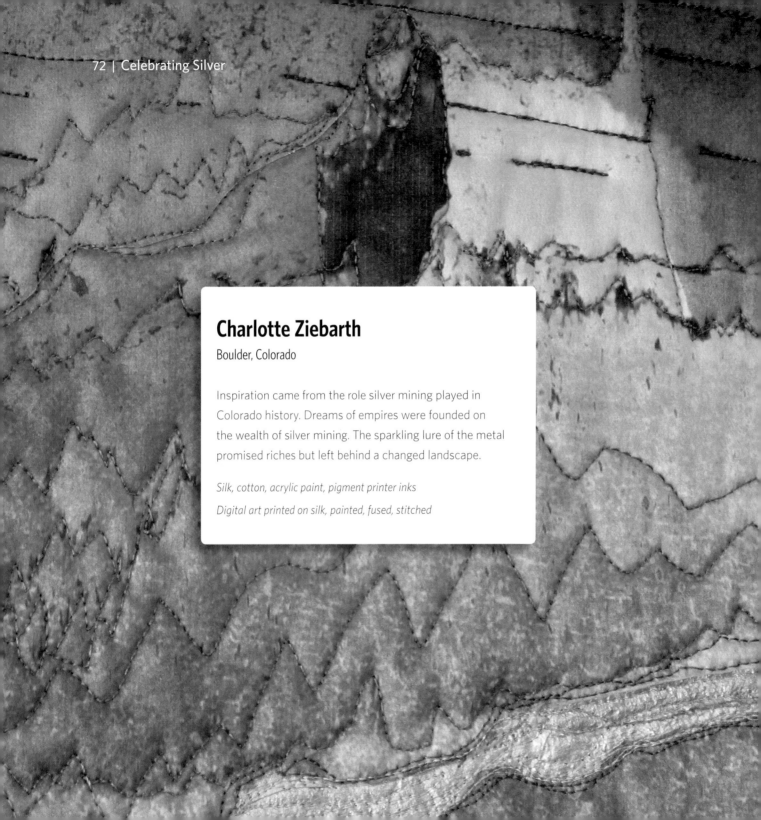

Charlotte Ziebarth

Boulder, Colorado

Inspiration came from the role silver mining played in Colorado history. Dreams of empires were founded on the wealth of silver mining. The sparkling lure of the metal promised riches but left behind a changed landscape.

Silk, cotton, acrylic paint, pigment printer inks
Digital art printed on silk, painted, fused, stitched

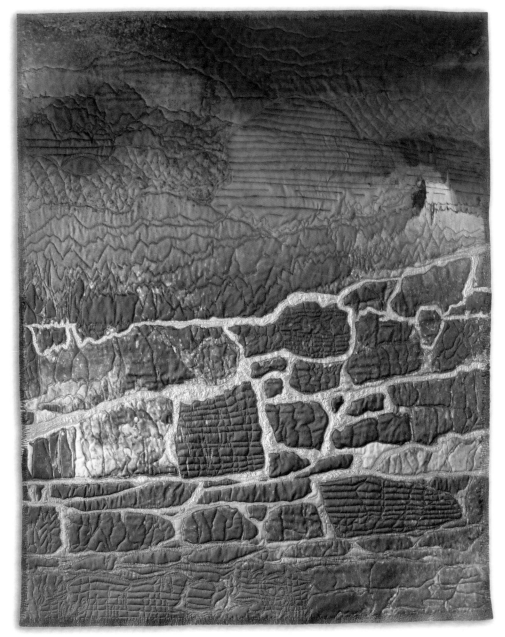

The Color of Dreams
48 x 39 inches